Meet Me at the Hipster Apocalypse

Devin Sheehy

Porkopolis Productions

Cincinnati, Ohio

DEVIN SHEEHY

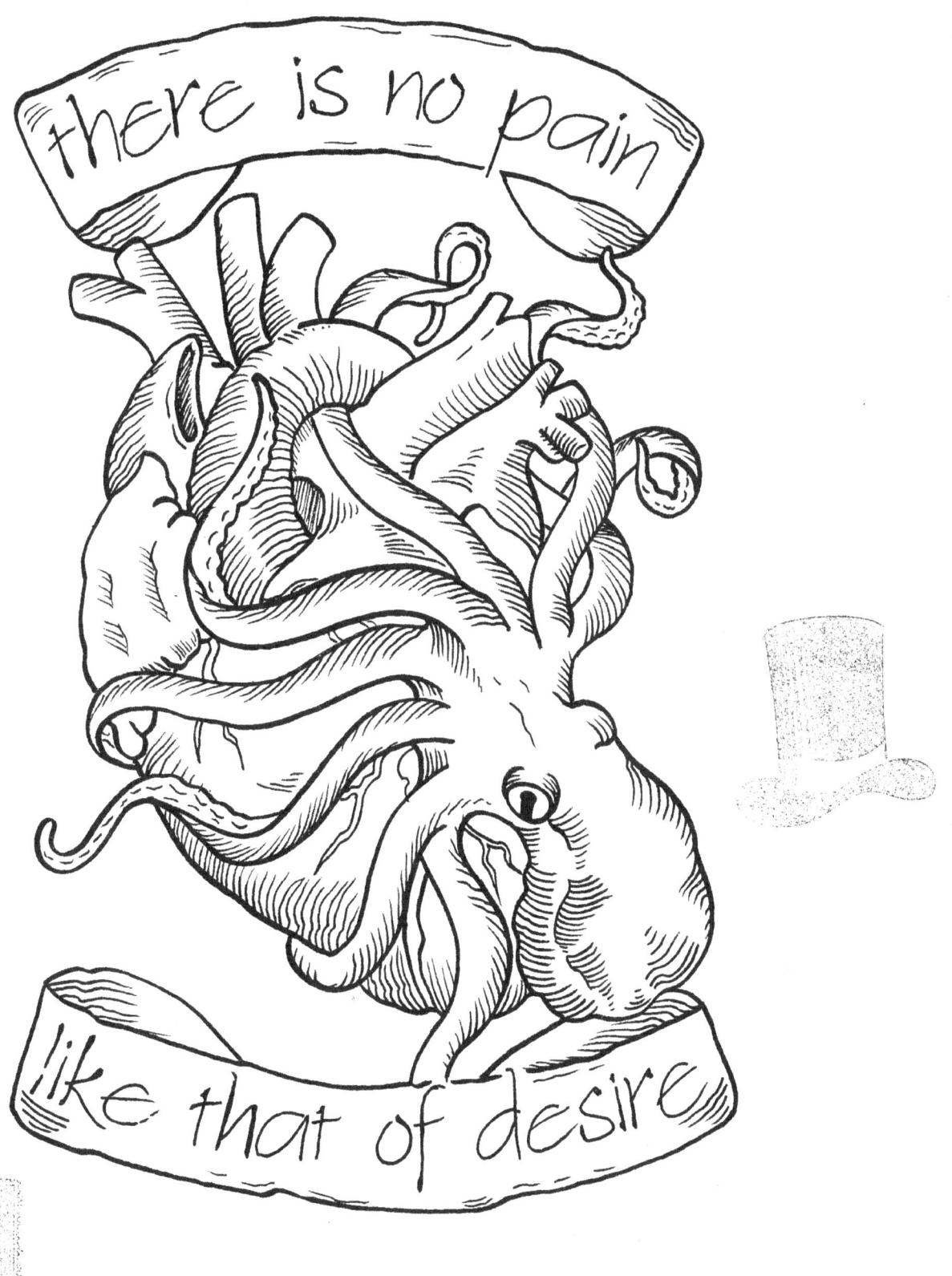

MEET ME AT THE HIPSTER APOCALYPSE

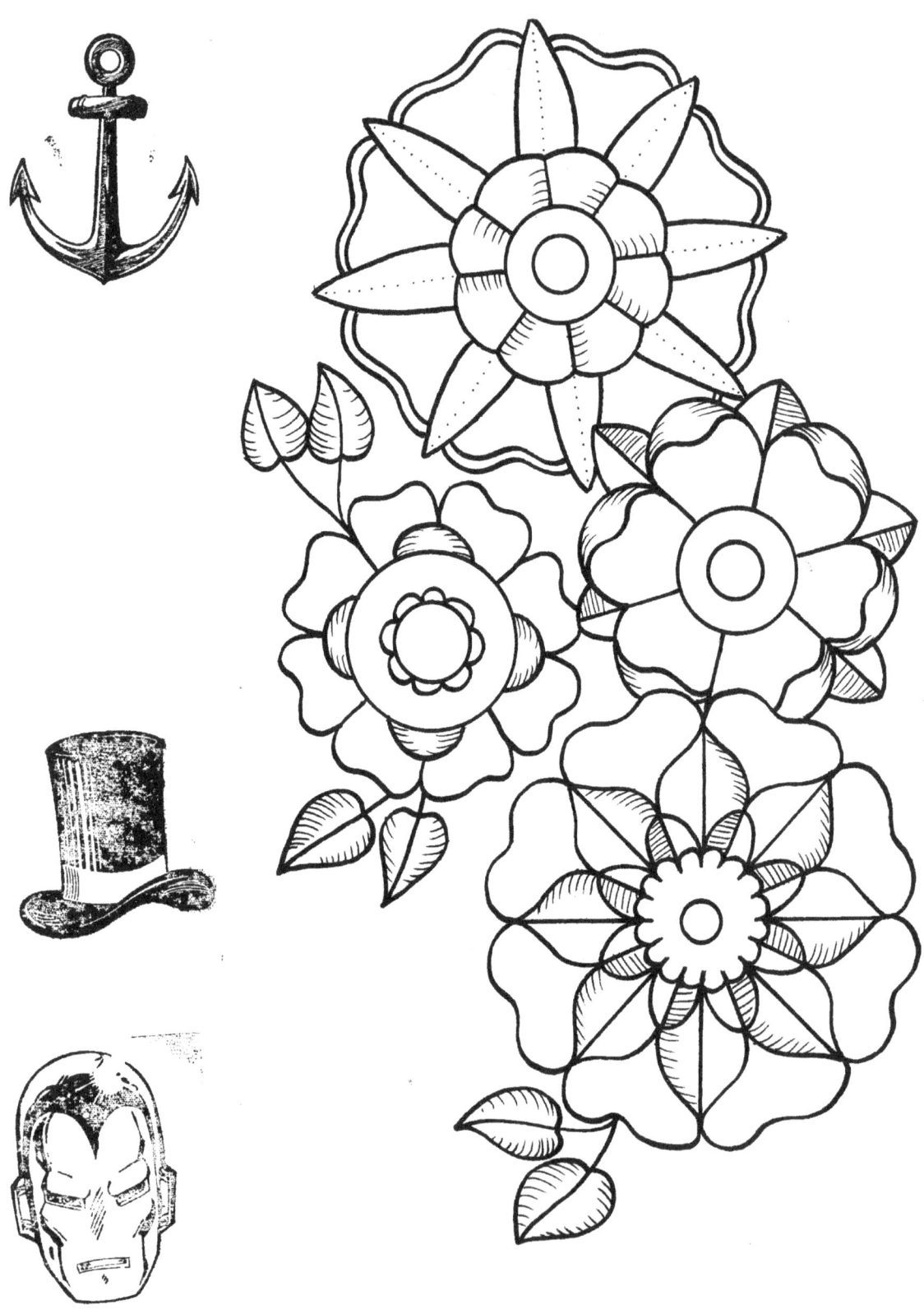

DEVIN SHEEHY

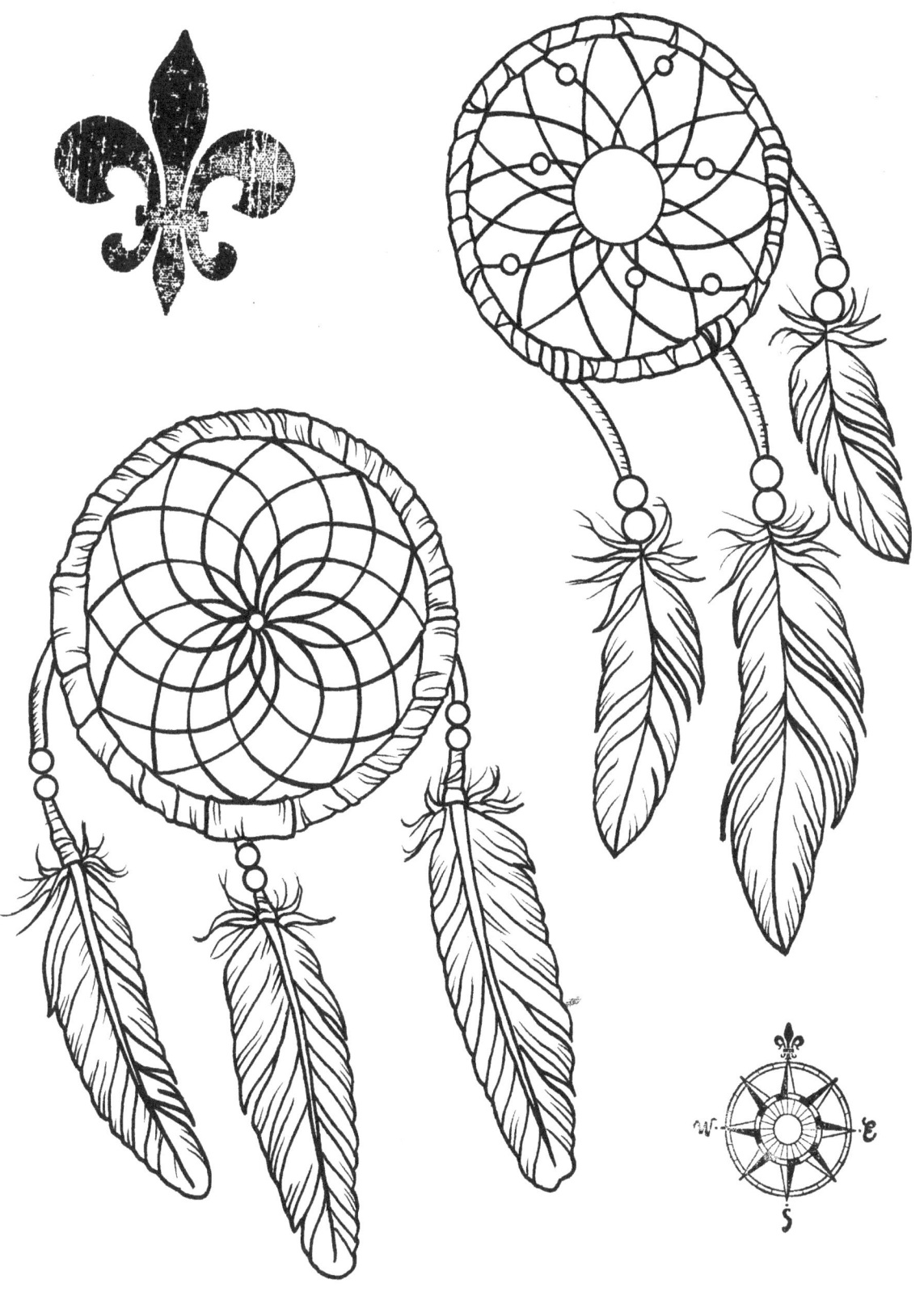

MEET ME AT THE HIPSTER APOCALYPSE

DEVIN SHEEHY

MEET ME AT THE HIPSTER APOCALYPSE

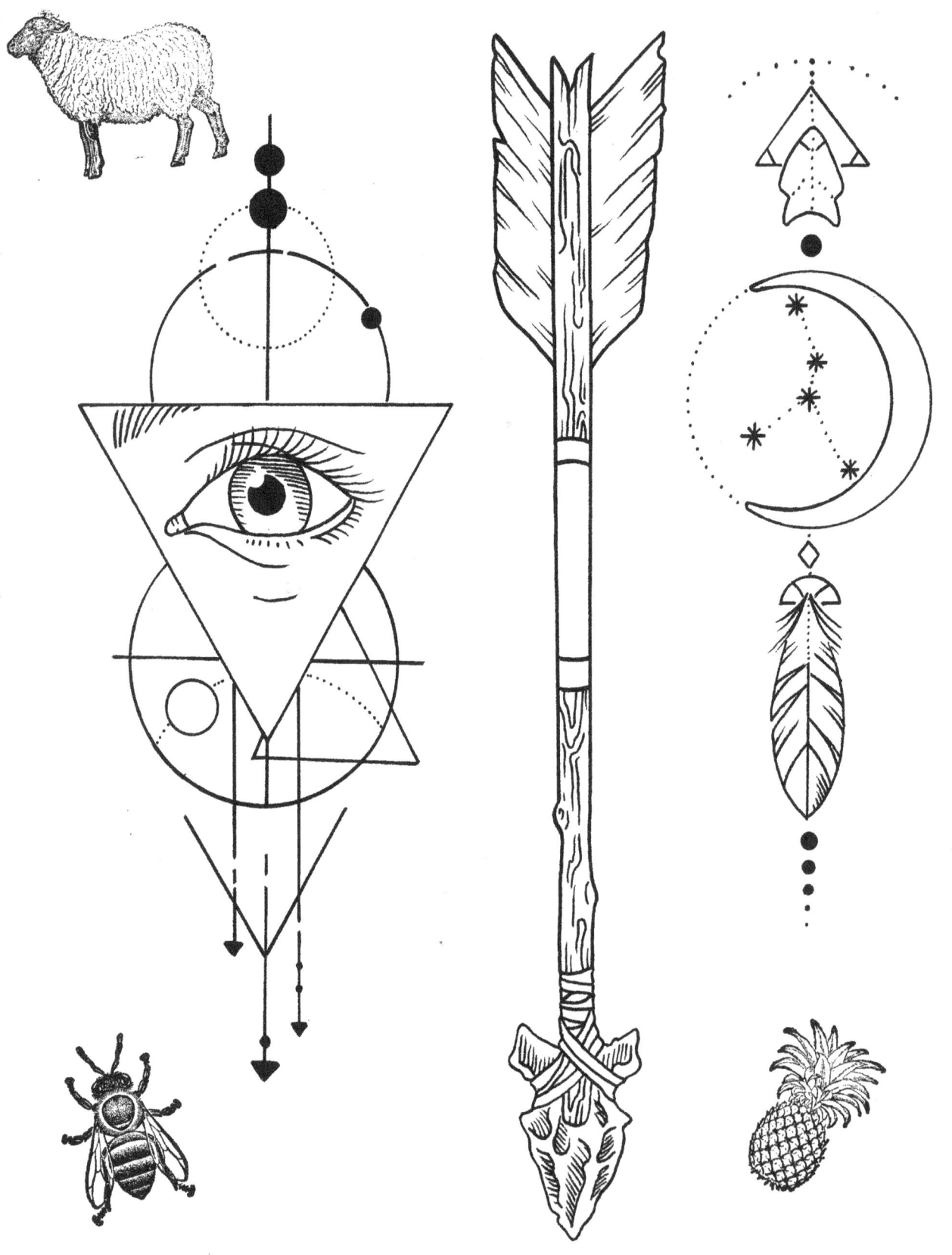

DEVIN SHEEHY

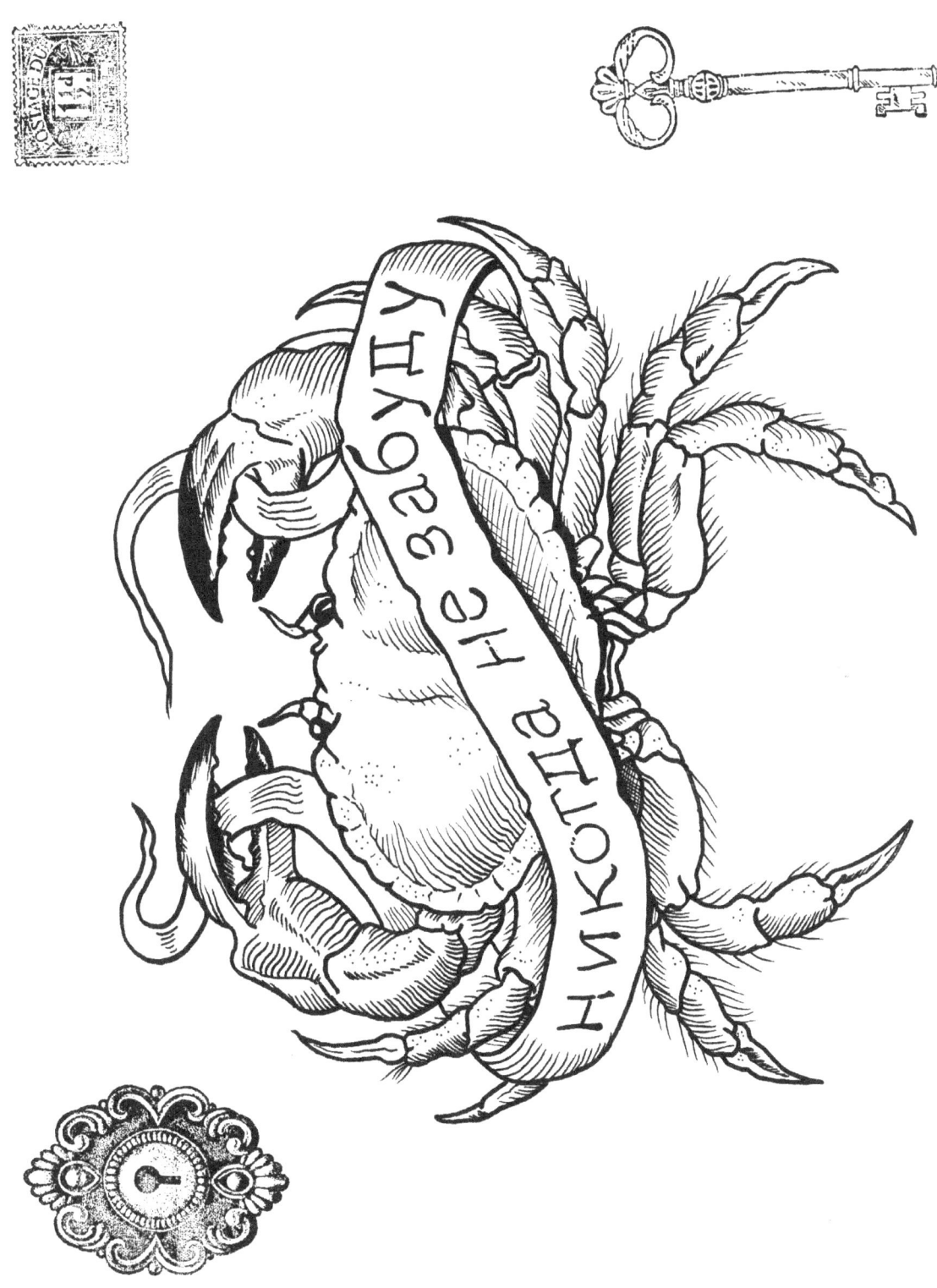

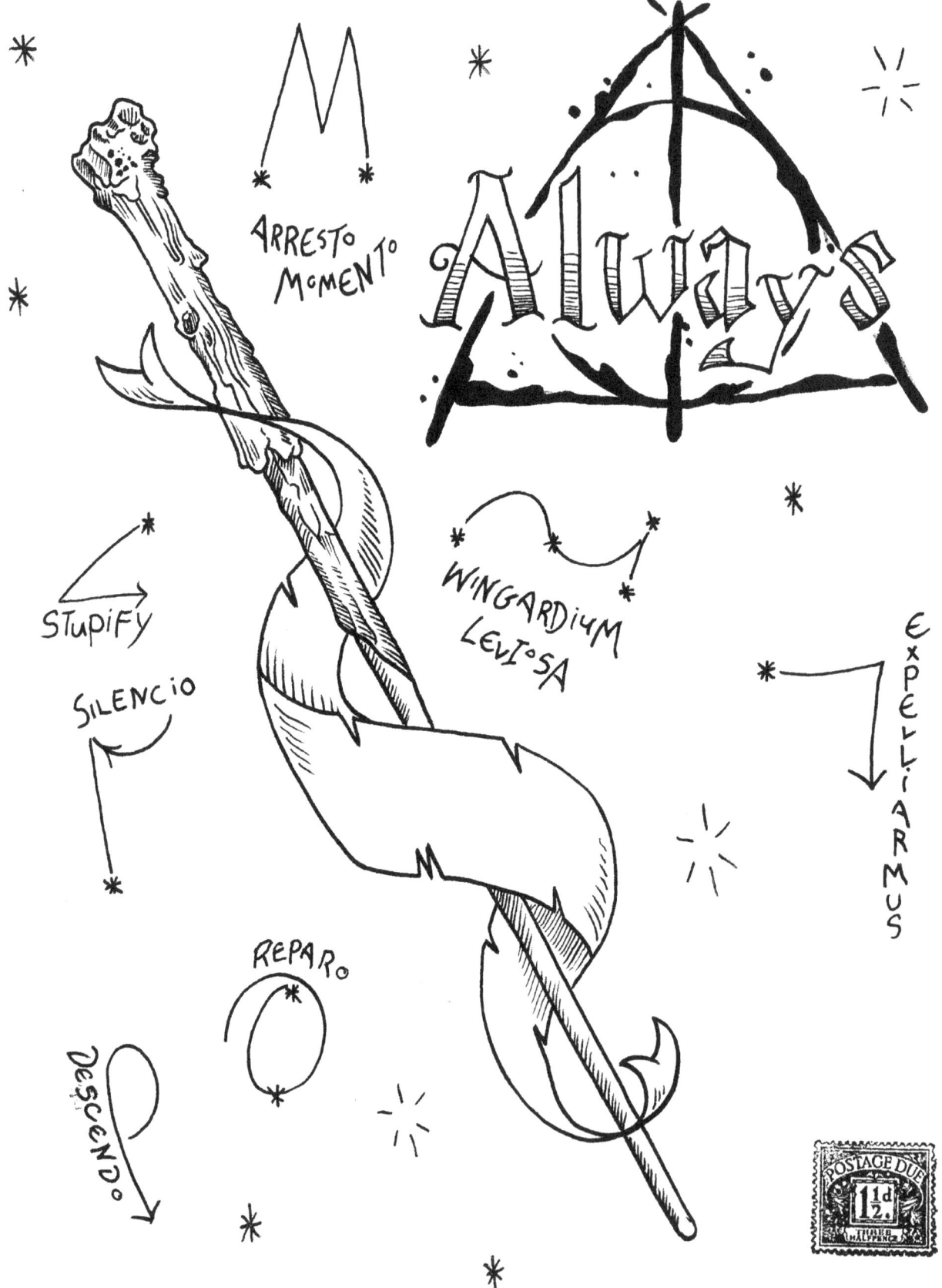

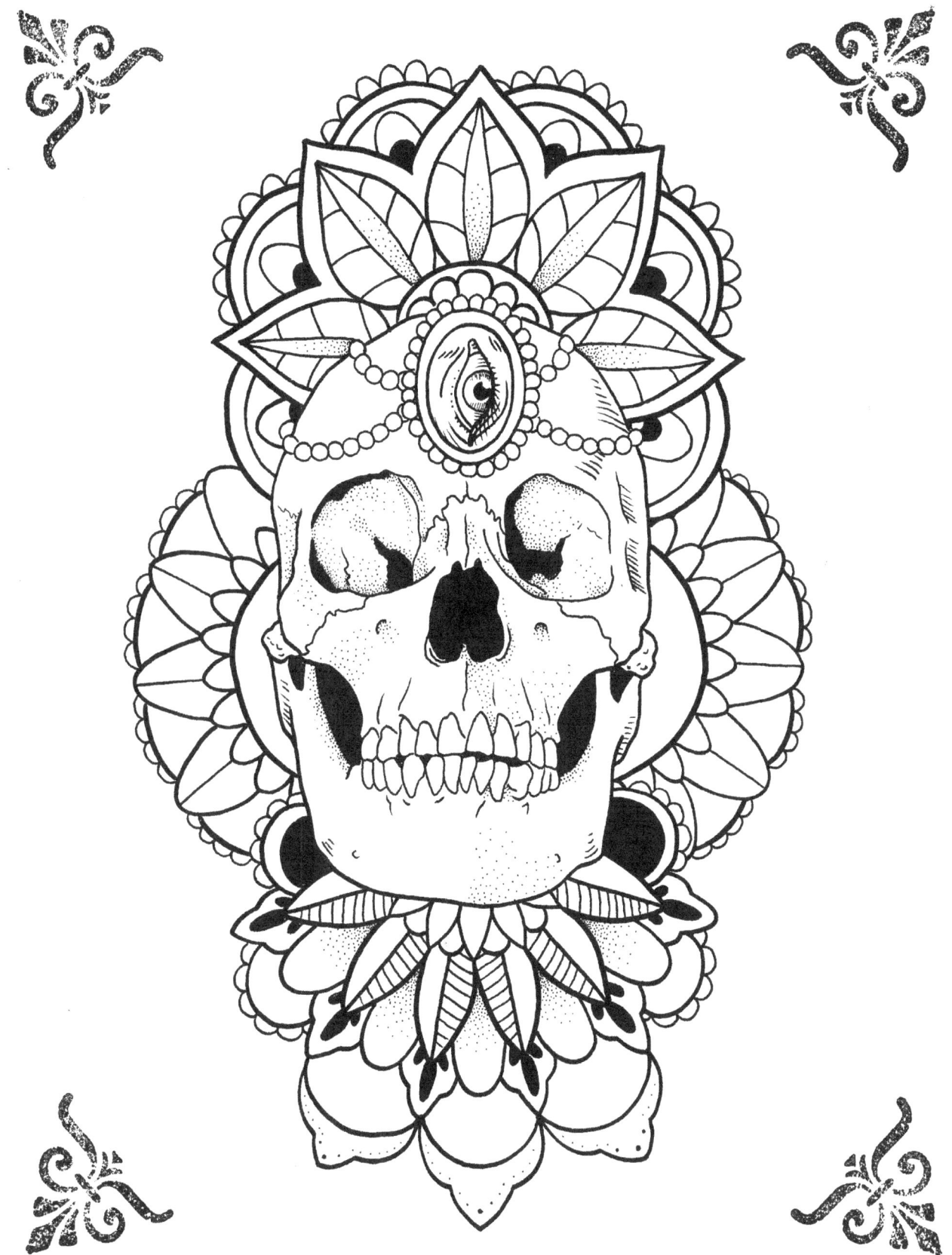

MEET ME AT THE HIPSTER APOCALYPSE

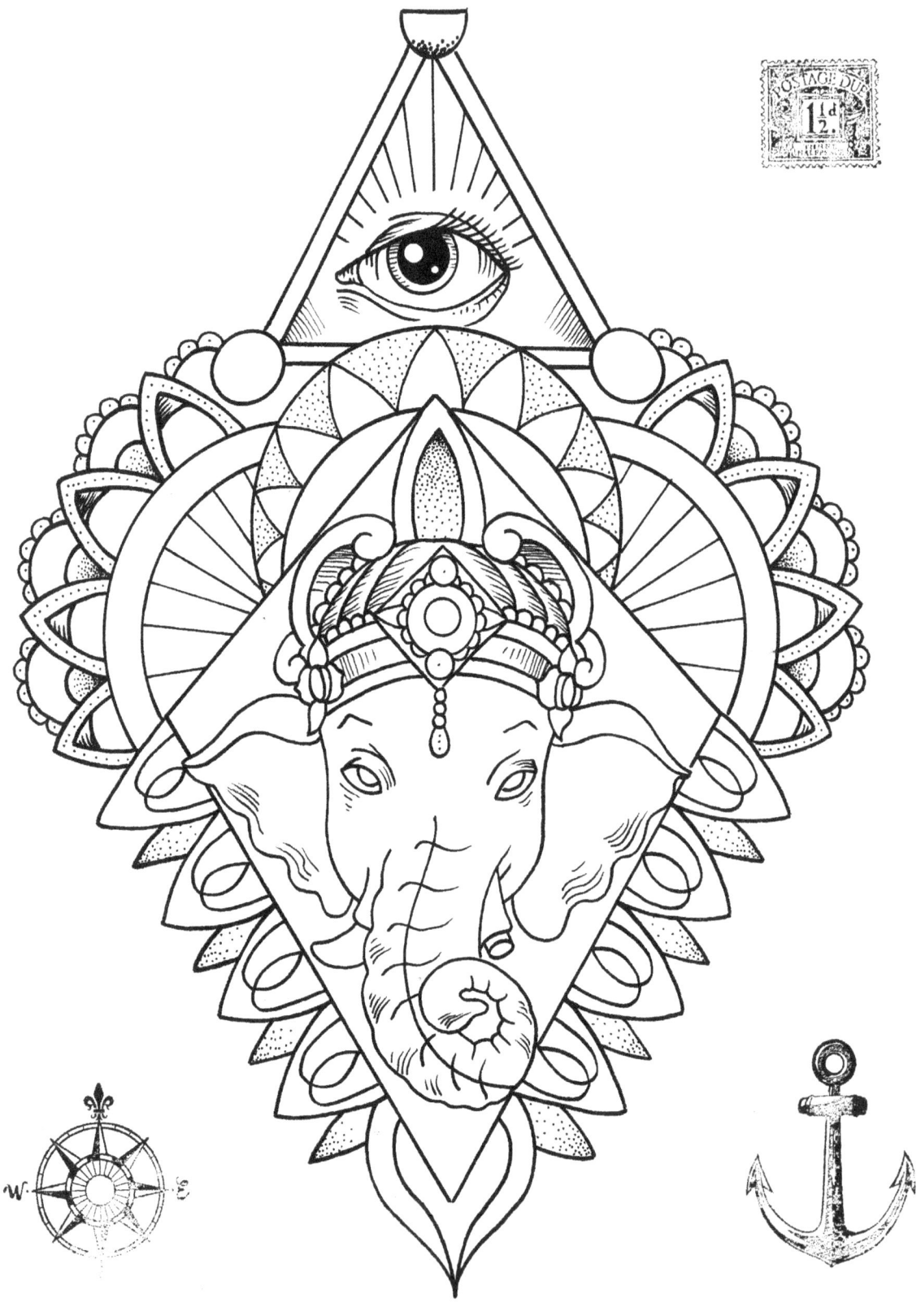

DEVIN SHEEHY

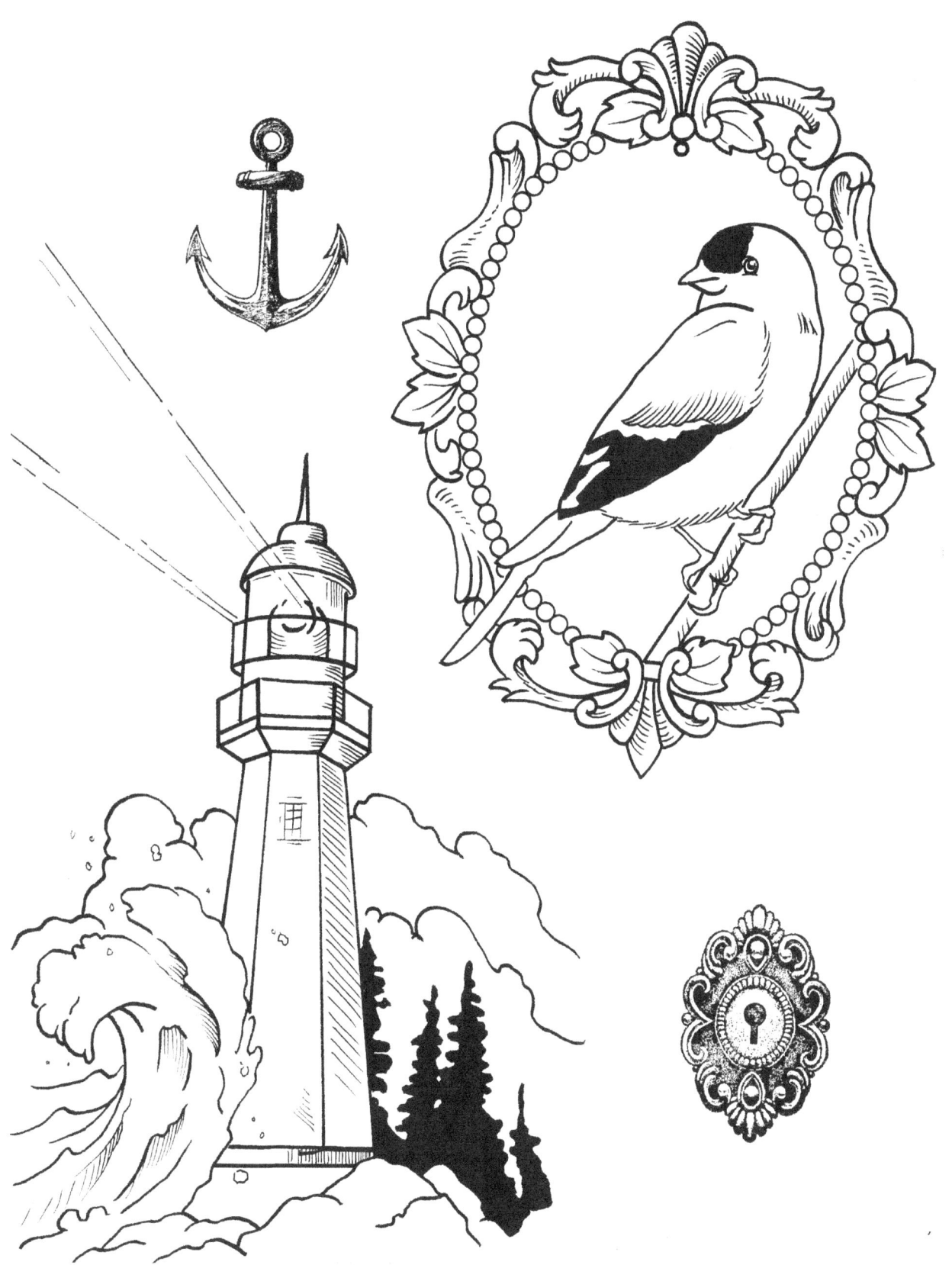

MEET ME AT THE HIPSTER APOCALYPSE

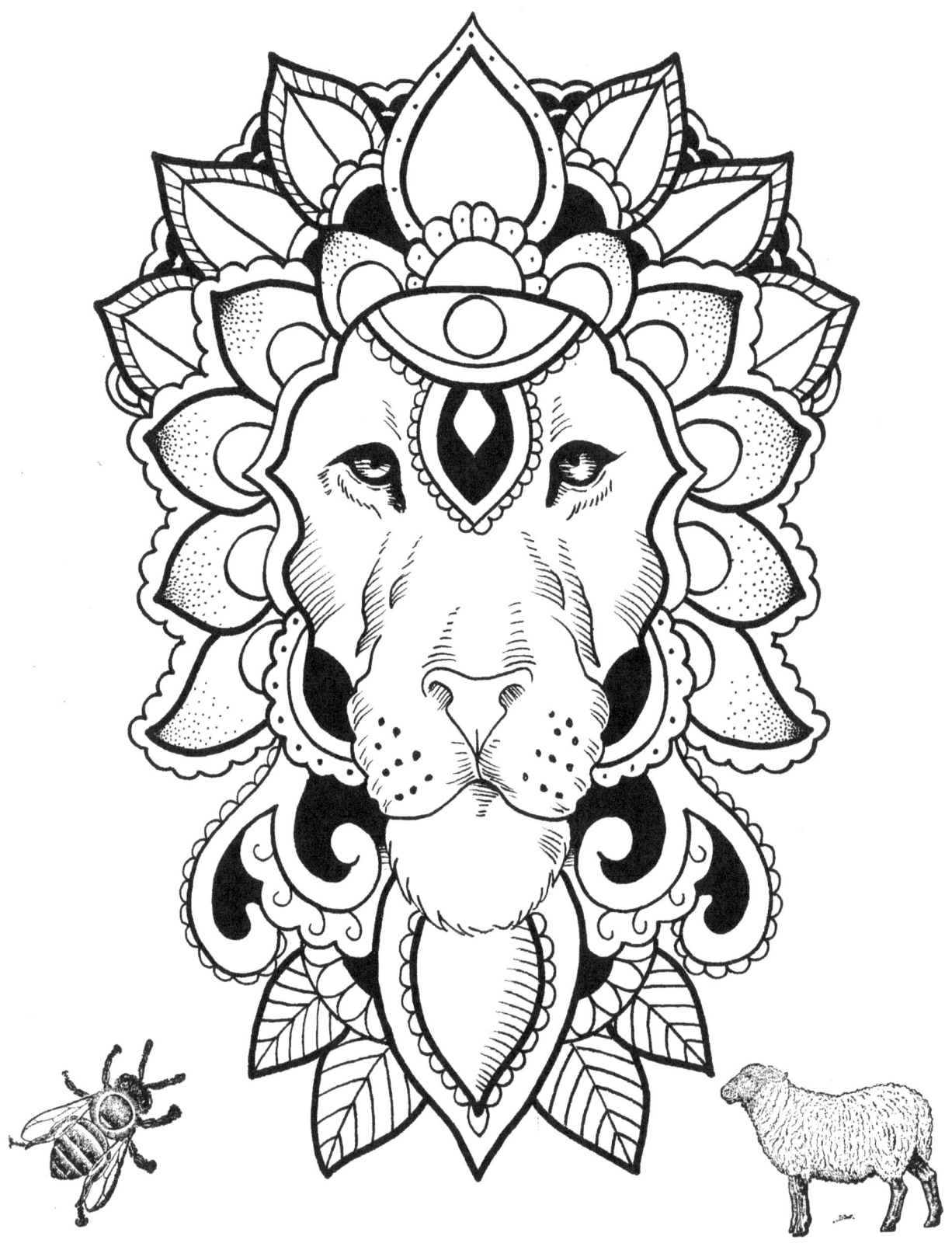

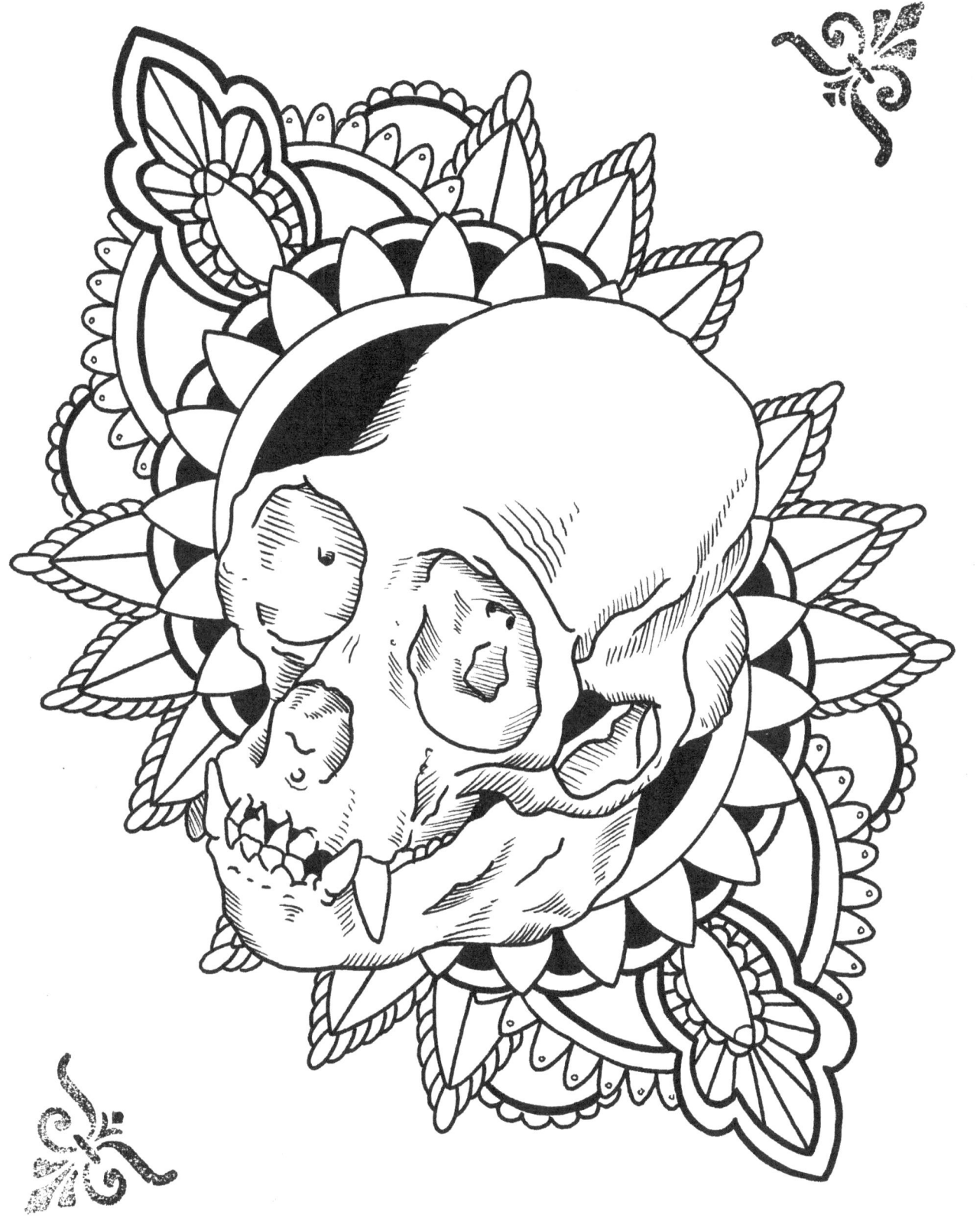

MEET ME AT THE HIPSTER APOCALYPSE

MEET ME AT THE HIPSTER APOCALYPSE

DEVIN SHEEHY

MEET ME AT THE HIPSTER APOCALYPSE

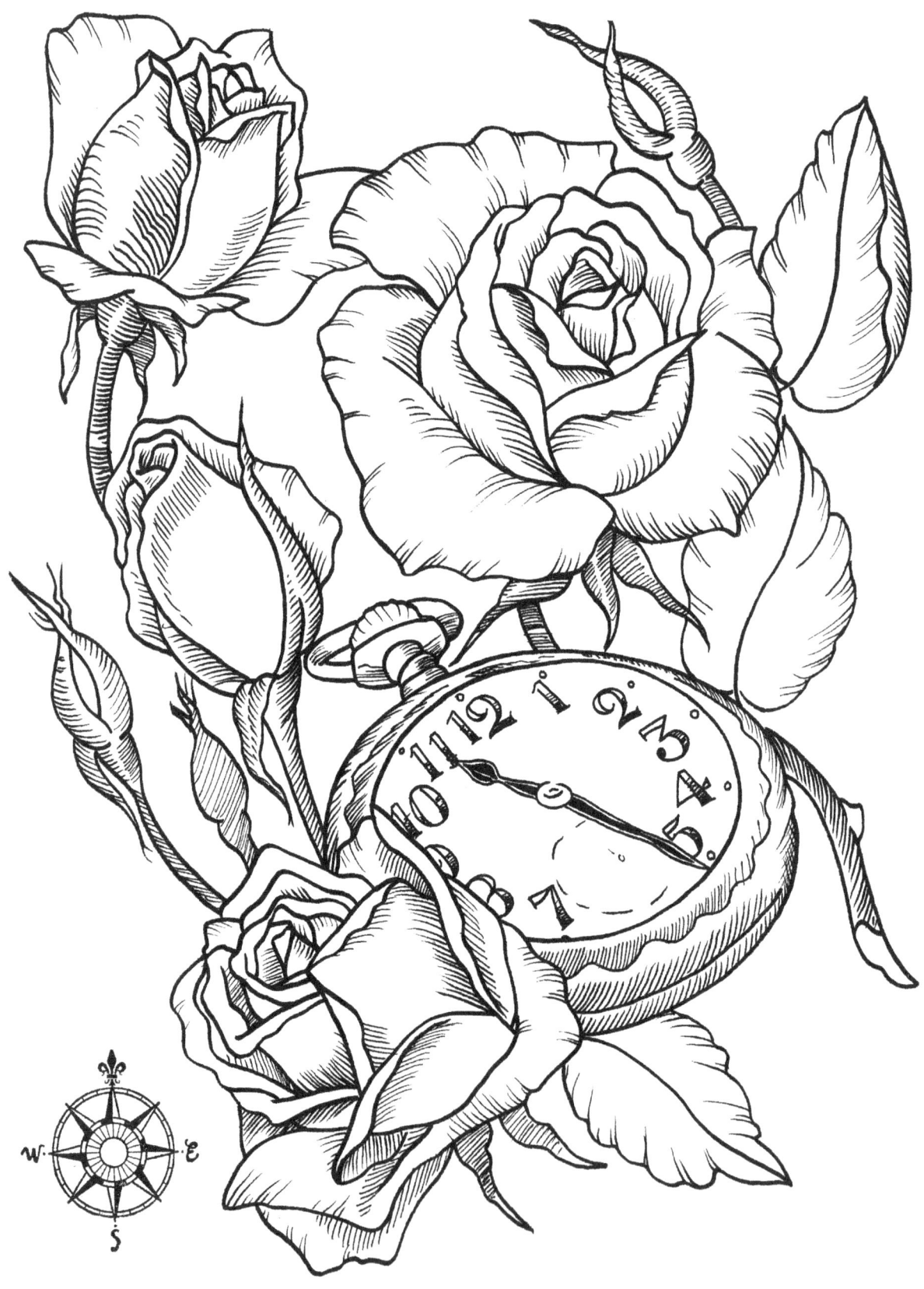

DEVIN SHEEHY

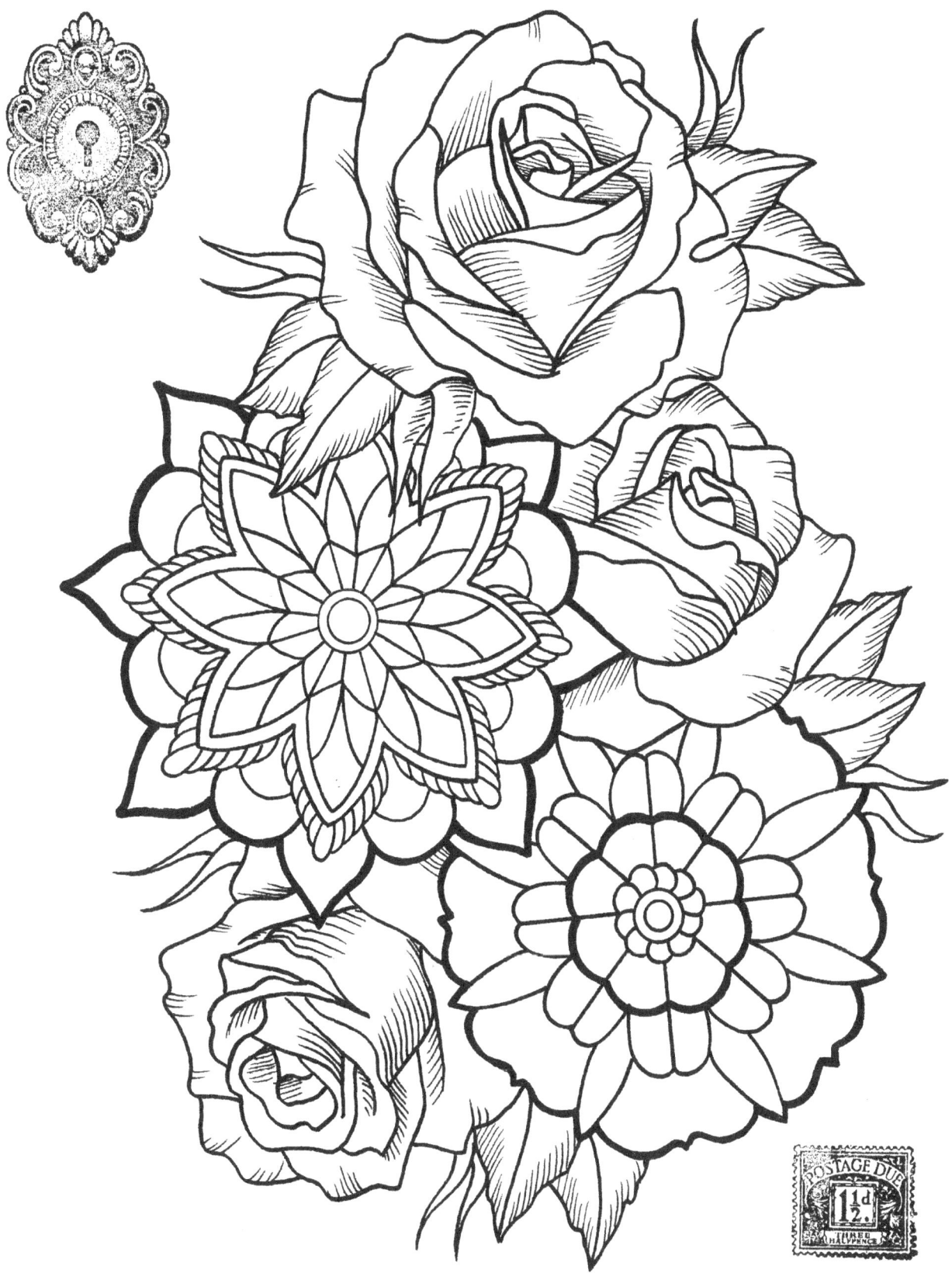

MEET ME AT THE HIPSTER APOCALYPSE

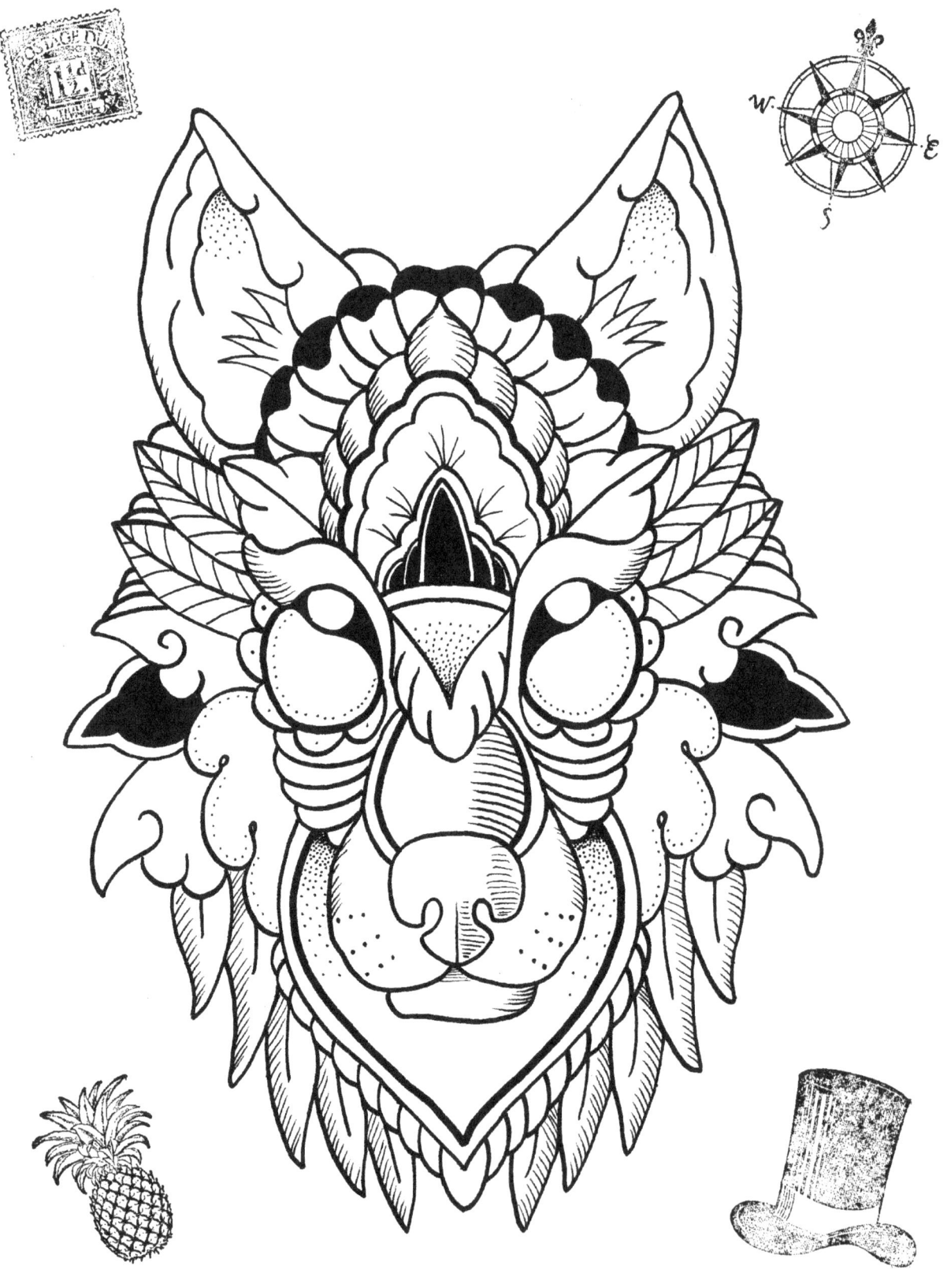

DEVIN SHEEHY

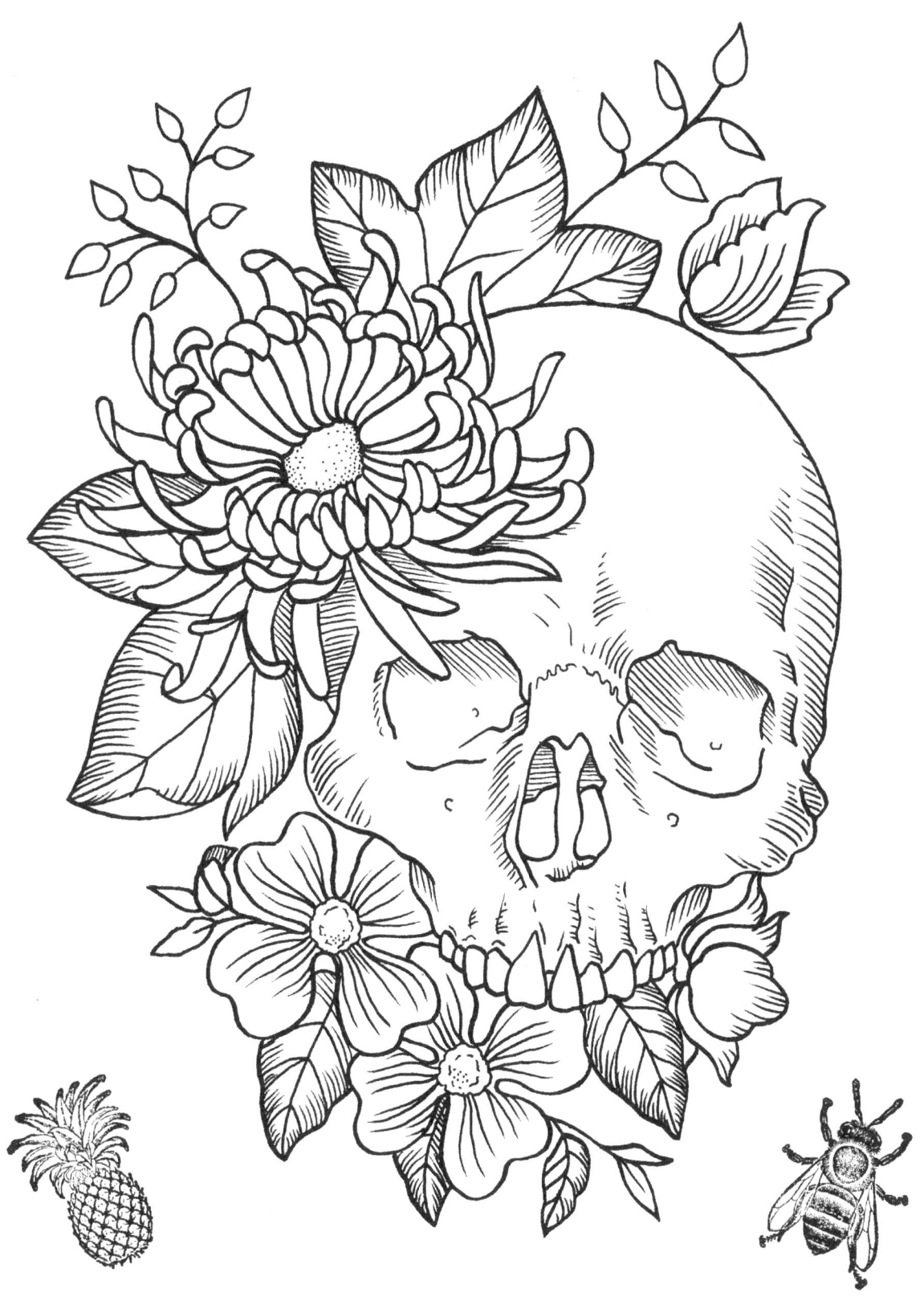

MEET ME AT THE HIPSTER APOCALYPSE